THE BASEMENT OF THE CAFE RILKE

THE BASEMENT OF THE CAFE RILKE

RAPHAEL RUBINSTEIN

HOUSE OF OUTSIDE

HARD PRESS, INC. 1996

Many thanks to the editors of *American Poetry Review, Bughouse, First Intensity, Lift, Lingo, Mudfish, O.blek* and *Talisman,* where some of these poems were first published.
"Prospectus" originally appeared in *Fabian Marcaccio, The Altered Genetics of Painting* (John Post Lee Gallery, New York, 1993).

Thanks also to Rudy Burkhardt for permission to use his photograph.

THE BASEMENT OF THE CAFE RILKE
Copyright © 1996 by Raphael Rubinstein

Published in the United States by Hard Press, Inc.
a nonprofit organization:
P.O. Box 184
West Stockbridge, MA 01266

The House of Outside Series
of first books is edited by John Yau.
This series is made possible in part by grants from
the Charles Englehard Foundation and
The Massachusetts Cultural Council.

Library of Congress Cataloging-in-Publication Data
Rubinstein, Raphael, 1955-
 The Basement of the Cafe Rilke/ Raphael Rubinstein.
 p. cm. -- (House of Outside first book series)
 ISBN 1-889097-07-1 (alk. paper)
 I. Title. II. Series.
PS3568.U184B3 1997
811' .54--dc21 96-37249
 CIP

for

E.B.

"I was cursed with a flat-footed, hard boiled, no-nonsense dossier, but now . . ."

&

T.A.B.

"At some point the words 'dress rehearsal' were left to fade."

&

J.Y.

"The precept we lived by was a slip of the tongue."

CONTENTS

1.

Prospectus
Courtesy Ashbery & Auden
Postcard
Vie Nouvelle
The Literary Life
The Old Option
Portrait Of
Short Letter To Pierre
What I Had With Me That Day In 1985

2.

Written On A Page I Forgot To Throw Away
Anti-Mirrors
Via Farini (Night #1)
An Account Of The Poem
Interior With Figure
Census
No Pasarán
Negative Contribution
In Lieu Of
Via Farini (September Songs)
From Now On, Once More
Three Waves
Agenda

3.

January 4th, 1989 And Later
Remains Of A Guest

Lines Written In Schipol Airport
Ukulele Music
Three Memories
Three Memories, II
Did I Get The Name Right?

4.

Requested Rhetoric
Late October
Sparks From A Hammer
Before We Met For Coffee
Landscape With Dead Child

5.

Landscape With Book
In The Meantime
Error And After
Rue Linée
Greetings From Filicudi
Accordion Music
Stray Dedication
A Restoration

PROSPECTUS

Foreseeing the false posture may be admirable
but who will there be to admire it
if all that such self-policing cultivates
are explanatory legends whose map was never drawn?

Should we look forward then to a tomorrow
of vacation from punctilious demeanor,
to an unshaven embrace, a sloppy kiss,
a song we can count on being remembered?

Better perhaps to gain neutral ground,
adopting a lingua franca whose forthright cadences
rule out both distrust and trust,
a face never widely known.

Days pass in a proliferation of visas
as something insists on staying visible,
infiltrated into the dissimilar world
it had once shadowed at a different distance.

COURTESY ASHBERY & AUDEN

Because life is short
we have to keep asking it the same question,
but the answer is hard
and hard to remember.

POSTCARD

Me (the scrawled message)
this room (the picturesque photo)
your eyes (the legible address)
and here, dear what's-your-name,
the postage stamp
cancelledbyanauthorizedhand.

VIE NOUVELLE

The clarity of the formalist life,
false but living, a perpetual autumn
wanting tomorrow to be always a little colder.

The gaze selects items
suitable for hanging on blindingly white walls.

Everything you possess is sleek and portable,
accessible as the face of an office clock,
easily converted into a page of lucid phenomenology.

The strict luxury of a text
containing ten lines.

The Literary Life

Who are we, associates of so many ill-advised,
 limply egotistical pronouncements,
to stand like monuments to sensitivity in some
 celebrated plaza?
There is an eel under the rock, there is something hidden.

Who are we to nominate ourselves for some high
 office of happiness
simply because we believe we have been able to penetrate
 into the inner meaning of things?
The countenance open, but the thoughts withheld.

Iron is sharpened by iron and the experiment may not be made
 upon a worthless body.
There is an eel under the rock, there is something hidden.

These trifles will lead to serious evils
 and hope is the bread of the wretched.
The countenance open, but the thoughts withheld.

Picture some Neapolitan beggar or homeless idler
 spreading equivocal rumor among the multitude.
There is an eel under the rock, there is something hidden.
The countenance open, but the thoughts withheld.

THE OLD OPTION

Why this one thinks that the songs come from somewhere else
is equivalent to why that one feels faint at the
 site of blood.

The old option was to find a car and drive
far enough for night to be night, for talk to hear itself.

Can't you see I'm offering you grounds to suspect
 that satisfaction born
like a fire in a country house when you're counting
 up someone else's losses.

And after—who knows why?—your non-sequential remarks
we quietly felt you owed us one proverb surely.

It's for naming who it's for, that tree-thronged bark
that comes towards exactly you, then spreads, because.

Portrait Of

Not the tenebrous widower,
not the king of a rainy country,
not the indecisive young bank clerk
sipping terse poems in drawing rooms.

So,
son of a mother,
son of a father,
father of no son.

Passport.
Appetite.
I like.
I don't like.

No.
Yes.
I love X.
I love Y.

I re-
member.
I for-

get.

Take
this.

Give

me

that.

SHORT LETTER TO PIERRE

Cher Reverdy,
 It shows a lot of *something*
to end a beautiful poem,
as you once did, with the line
"talent is worthless."

WHAT I HAD WITH ME THAT DAY IN 1985

It's not worth the trouble
to complain about distance. Distance
is barely worth mentioning.

Complaints are not magnets

to say that the limping pigeon
or the blonde girl
lying on the sunny grass
make me sad
leaves everything where it was before.

I light another cigarette.

5:30
I am about to escape you,
Place des Vosges,
for a hotel two blocks away.
Bye, limping pigeon.
Bye, supine blonde.

Sunglasses, *Lyres* by Francis Ponge, notebook, pen.

WRITTEN ON A PAGE I FORGOT TO THROW AWAY

A stage in a perfectly restored 19th-century theater,
the curtain pulled back to right and left creating
an elegant frame for what is happening.
Years designating different things for each of us.
This is mine because I am doing (and have done) it,
that is yours similarly.
Standards were ratcheted too tightly,
futile as the supression of public drunkedness.
Now this is partly yours
if we can agree on a working definition of possession.
Across the boulevard from here
on a sharply angled corner
was a Hungarian restaurant I ate in in 1974 or '76.
Let me remind you why these ploys are ruled out.
What does he have in there?
Yes, we are going to concentrate once again
on—how shall I put it?—not the scenery
picked out by the headlights but the talk between
passenger and driver.

ANTI-MIRRORS
(AFTER MICHEL LEIRIS)

I'll look at meadows
and I'll look at trees.
I'll look at anything
that isn't me.

Via Farini
(Night #1)

Perdu, half of this evening during which I could already
 have moved far beyond these first lines.
Perdu, many half-evenings and whole days previous.
Perdu, everything that might have been written on them.
Perdu, hundreds of girls I didn't go out and meet on them.
Perdu, come to think of it, evenings when I *did* go out
 and meet girls, evenings when I *did* write.
Perdu, the desire to list all things perdu.
Perdu, admiration for this poem.
Perdu, the moment I wrote the first line.
Perdu, that briefcase containing 33 years' worth of days.
Perdu, this stanza's chance.

Trouvé, the empty beauty of the room I'm in.
Trouvé, the sound of the family across the courtyard
 jabbering to each other over dinner.
Trouvé, distance from the place where I could
 still be reached.
Trouvé, the waiting elegance of the black coat and blue
 umbrella hanging in the brightly-lit entryway.
Trouvé, the brightly-lit entryway itself.
Trouvé, peace.
Trouvé, quiet.
Trouvé, a beachhead on the well-defended continent of…

An Account Of The Poem

I present myself with the evidence
of the crimes for which I am
perpetrator, victim, jury and judge

I stand there brandishing at myself
a treaty I have failed to honor

I dig the grave
lie in the grave
fill in the grave
pay for the tombstone
deliver the eulogy
write the elegy
forget to visit

and once was twenty
and read Ungaretti
and had a heart

Interior With Figure

I see her waiting for deliveries and not understanding
how others might take offence at so much convenience.
That claque or cohort,
if her reasoning is sound,
(as it may well be even if
the circumstances, so elegant,
in which it is given form,
are little to my liking)
is seeing to it that this is how
the directives are phrased,
and woe betide you who
attempt otherwise,
as for long I did
not knowing the reasons against.

One more mode added
and to whom? you ask
harder, farther.

CENSUS

He, a man who knows his own mind.
She, a woman of infinite resources.
They, a charming couple.

You, a real mystery.
I, a minor character.
We, the pinnacle of success.

We, the raison d'etre.
He, the ghost in the machine.

I, a loose thread.
She, the thorn in my side.
You, a cipher.

They, without whom none of this would have been possible.
They, our dearest friends.
We, the people.

You, a missing element.
He, a shadow of his former self.
She, a shadow of his former self.
I, a dream of motion.

I, a thorn in her side.
They, the madding crowd.
She, a person of no fixed abode.
We, the loved ones.

He, a dangerous character.
You, a scandal waiting to happen.
You, a passing stranger.
I, a stray thought.
He, our hero in disguise.

They, the enemy.
We, the enemy.

She, the score-keeper.
She, the enemy.

You, the enemy.

We, the negotiators.

I, the undersigned.

They, the powers that be.
He, the boss.

No Pasarán

Sometimes, to rise above clichés
(which is, after all, our highest duty)
it becomes necessary to seize the commonplace
with all the strength you can muster.
Here's a plain table in a nondescript café
in some overcast city anywhere in the West.
Here are these 15 minutes or so
between an office and the onset of evening.
Here's a freshly purchased ballpoint pen
and the back of a piece of paper
filled with flight departure and arrival times.
Two decades past ejaculation #1
these constitute my first line of defense
against the besieging forces
of a miserable literary ambition
whose victory would install
acres of grandiose mausoleums.

NEGATIVE CONTRIBUTION

Let it go without saying (except this once)
that above every poem I write
are more or less the following words:
these lines won't help put bread on anyone's table
but at least not on mine either.

In Lieu Of

Details, once kept firmly minor
by the panoramic, lofty tilt of your smooth chin,
mushroom into gluey obstacles.
Or can you suggest a better way to describe
the utterly useless *adultification* of life?

It would be (illegible) to simply state why
the ten lines that have occurred to me
are not the ones I can bring myself to transcribe.

I had an idea earlier today.
How nice to spend the next six months elaborating
 its many ramifications.

When the surplus leaves fall, sweet friend,
we'll sketch, with this chalk, this tree.

VIA FARINI
(SEPTEMBER SONGS)

I.

1.

The false tone that can't be recognized until it is used.
Today viciously revises yesterday.
Agreements fade.

Monday she wore a knee-length skirt and sweater.
Tuesday she wore a short leather skirt.
Wednesday she wore a knit dress.

Each hour leaves a litter of serious revelations.
I've succeeded in forgetting what I owe to others.
Several doors are useful.

2.

The duration of the performance is roughly set.
No one knows if or where your attention drifts.
I care and don't care.

The door closed: you savor the epic of your now.
The door open: you breathe in their and its objections.
No door, no hope.

Don't start thinking about what you're going to do when
 this is over.
What difference would not writing that poem in 1976

have made?
Like much else, the advent of an intermission is hard
 to discern.

3.

The false tone can't be recognized until it is used.
Tuesday she wore a short leather skirt.
Several doors are useful.

The duration of the performance is roughly set.
The door is open: you breathe in their and its objections.
Like much else, the advent of an intermission is hard
 to discern.

Last week I faced an ethical dilemma in Paris.
The precept we lived by was a slip of the tongue.
Agreements fade.

II.

1.

Like breath, saliva, tears and morning, here you come again.
One minute nothing, the next something.
The title was "Reasons for Living Happily."

One tonight, and one last night, and one the night before.
It's been years, but I'm teaching myself to again.
Fugue rather than litany.

Bringing the mind to the point where it begins to
 strain, then relaxing in a exhalation of clean ink.
Sometime later this year I'll be having lots of fun.
They're not all bad.

2.

The first one that is really the 10,000th, at a rough guess.
One dichotomy snapped off from the surrounding thicket.
Habits are for breaking, and no one knows why.

This miserable reflex of ventriloquism.
What were the evaporated passions that caused
 the marble figure to be deposited in the park?
Leaving out the piece that would complete it is too
 easy, but what isn't?

Something that looks like you didn't care—you did,
 but in your own way.
Each utterance advances itself towards a language
 which wouldn't be caught dead saying it.
Scales working overtime.

3.

The melodrama of eloquence was behind us.
More would follow later no doubt, on some less
 matter-of-fact day, when spirals of cindery birds
 would spell out the thermal letters of a yet
 unnoticed name.
For the moment: notation and calm.

Not much of what had been looked forward to materialized.
New bêtes noires issued from their holes daily,
 feathers stuck to their lips.
With our spades of envy and our
 childhood-remembering perspiration we dug deeper,
 making news out of rocks.

An assembly of voices, no one of them traceable back
 to either deed-holder or architect of the hall

that has been lent to them.
An experiment in acoustics.
At some point the words "dress rehearsal" were left to fade.

From Now On, Once More

A habit of vagueness passing too long for inspiration
that and the days beginning to attenuate in late February.

From now on I must remember to add the names of months
to the growing list of forbidden words.
Full of suggestion
but wholly unforthcoming about how one arrived at them,
they too swell with wandering impatience.

This is an evening to sit out until
mere wishing evaporates
but—how well you know it
without ever once having attempted
to push the aggregate into visibility—
such dreams of arrival
would require more indifference
to the coming profile
than you can wish or manage.

Three Waves

If you can think of a simile
that has never been used before
(at least to your knowledge)
then the ocean can enter this poem.

What, exactly, is so unbearable
about poems in which the poet
addresses him or herself in the second person?

Rephrase:
no ocean
without a new way of saying ocean.

Agenda

That was the 18-month period
when every line written within our borders
was unspeakably bad

including (I'm devastated to report)
my own.

In the years following, conditions generally improved
though too late for thousands of small producers
whose investments rotted

like strike-bound shipments
of fish and fruit in an August sun.

Now it is time to think about X.
Now it is time to think about the heavy hand of Y.
Now it is time to think about how much Z has achieved
 through pure stubbornness.
Now it is time to think about the probable negative
 judgment of A and how little it will matter
 in the long run.
Now it is time to send a dull postcard to B.

Dear C, your shadows and flesh,
a life of lousy news items and prayers
somewhere.

January 4th, 1989 And Later

Of all the poems I could write this morning,
this is far from being the one I want the most.

Remember, how the mesmerism of the empty years
hounded one of us into silence?

The sun is blinding the cold river.
Soon the other of us will hear the windows' rattle
and taste the taste of anger,
couched in refusal.

REMAINS OF A GUEST

Yesterday afternoon I was certain
how today's poem, long and for you,
would read. The only thing left of it
is this trace of detoured intention,
insubstantial and arcanely emotive
as a few strands of red hair
left in a bathtub.

Lines Written In Schipol Airport

They are both mistaken, gravely, somewhere at the heart of their projects.

I have no project, but this doesn't mean that I too can't be gravely mistaken, or lightly.

I open the curtain. I open the window. It is me doing these things. It is you I'm telling this to.

What jettisonings it's taken to have gotten here, and I'm still hurling things out the window, littering the country I've passed through.

I seem to have exchanged Wallace Stevens for Charlotte Gainsbourg.
Two years ago, when I still *smoked* and *drank*, when I was still *with* X, I saw such an exchange as the ticket to a new life, assisting at the destruction of all that dragged on me. Its appeal was similar to that of "clubland" circa 1979, except that this time the swerve was of the imaginative order—I could enact my nihilism, my embrace of the opposite of what duty implied, on paper without the complicated process of putting it into practice. The only actual result (only! hardly!) was the end of my life with X. The coin of two years ago was not sweet Charlotte but Swing Out Sister.

Yesterday I read a text by Denis Roche (from 1977) for Bernard Dufour who did the paintings for *La Belle Noiseuse* which we saw a few weeks ago and which featured Jane Birkin who

happens to be the mother of Charlotte Gainsbourg.

We had lunch on Thursday with A at his attractive new apartment overlooking the Senato. We told him about the lousy installation of the show of young artists we saw on New Year's Eve—which was good news insofar as A and I felt unjustly left off the prize committee by our two supposed friends Y and Z—and then A told us that the sponsor of the prize turned out to be the biggest arms manufacturer in the country. We laughed at the justice of it all.

An idea to return to: the written portrait. My idea, maybe ten years ago, probably longer, to sit in a room with my subject and write whatever came to mind as I studied them. In contrast, Roche has his subjects deliver to him a ream of written pages from their home, out of which he then constructs his linguistic mosaic. I am also thinking, now, of HM's suggestion last year that instead of directing others to write a book for me, I should have them tell me what to write.

I turn up the volume and look around me, half-drunk.

> "*Oh bébé*"
> thump-thump
> *delicieuse enfante*
> the longeurs of society prior to 1967
> title of my next book:
> *Sonnets for Charlotte*

UKULELE MUSIC

Drunken afternoons in Spain
Drunken afternoons in France
Drunken afternoons in Italy
I once wrote a poem titled
"Daydream While Listening to *Walls and Bridges*"
My wife is sleeping on the sand nearby
At 17 I worshipped *Tender is the Night*
At 19 *Love & Fame*
Imagining some rich and arrogant artists I know
I sharpen my knives and let another bottled shout drift off.

THREE MEMORIES

This book (*Tripmaster Monkey* by Maxine Hong Kingston) happens
 to be set in a place (San Francisco)
 and a time (1968)
where I passed my thirteenth year.
I remember buying Ralph J. Gleason's *The San Francisco Sound*
 in City Lights.
I remember jacking off to a photograph of Cyd Charisse
 (concentrating mostly on her legs)
in the T.V. listings of the *Chronicle*'s "pink section."
Perhaps this is also the moment to mention the girl in the
 patent leather raincoat
on the cover of *Rommel Drives On Deep Into Egypt.*

THREE MEMORIES, II

I remember excitedly playing a 45 of "Holidays in the Sun"
in the fall of 1978
for Sharon Kanach
former student of Nadia Boulanger, Olivier Messian
 and Yannis Xenakis
in her apartment out past Place Clichy.
I remember her inability to distinguish it
from any other "rock record" she'd ever heard.
I remember staring at that whirling black disk
with enough furious impotence
to power a 2CV.

Did I Get The Name Right?

This television screen
and a sheet of paper
are flirting like drunken tourists.
Teodoro Bastidas, padre,
here I am in time to hear of
the first five minutes in Cuarto 418
at the Caracas Hilton
the death of your 5-year-old daughter
by a stray bullet
in one of the hillside shanties
whose lights flicker
outside the window
of Cuarto 418.

REQUESTED RHETORIC

Revealed: The why of images interposes itself, like a threatening iron scythe, between the small hill I'm standing on and the verdant, rivulet-streaked plain.

Poetry, frail stepchild abused by many a troubled parent, shudders on the trees like a November leaf.

Rewritten: In the room where names gather it's too dark, but where vapors and aromas circulate between open mouths, the light is too swollen with flanneled love.

To dribble such eloquence is easy if one is in the mood, but any subject that the weekend guests would be able to regal their co-workers with on Monday morning remains scarce, like deer on the roadside at night seen only by other passengers.

Oh Mr. Sky, to whom I deliver this late package, anger and sincerity will have to wait for meaning to shake off this drowsy afternoon.

LATE OCTOBER

It was only in a dream that the library whose fiery destruction you like to drop hints about ever existed.

Telling the whole story seems everyday less likely. If this helped reconcile you to the narrowness of our conversational subject matter and the elliptical style we have grown into using for this homegrown negation, it would be all well and fine, but it hasn't and every night, planting yourself in front of yourself, the old hunger for panorama is still there,

Tell me what to do; tell me what to tell; give me that blueprint!

Sparks From A Hammer

1

Authority, n.: the power to allow or forbid the use of language, usu. exercised over oneself.

It must be kept in mind that to ask "may/shall I speak?" is already to have said "yes." But this, let us sensibly note, still leaves other questions unanswered: how shall I speak? what shall I speak about? to whom shall I speak? for how long?

To speak, v.: a metaphorical term for the act of writing.

2

Of course there are days when apology and deflection are not necessary, when the hand closes around what the eyes want without first taking its own fingerprints and studying them for signs of permission. There are even nights like that (though this is not one of them).

Proposition or cadence.

3

Something moves across the scene like a bulldozer (a bulldozer?) sweeping away the carcasses of the common birds you have dropped from the sky.

Now land and sky are yours, if only as an empty waiting-room of bleached rectangularity, a page beginning to recover from the necessary annihilation.

4

Is this how we had to live, acting as if our fiery murmurs were burning someone else's hand, this smoke filling a different home? Anyway, one can't complain about it, not if it means joining the weekend pagans and attending the theater of self-immolation. Let us wish only that the marionette hear the music, that cold touch heat, that steam cleanse and redden us.

5

I'm tired of our differences—not the ones we were born with, not the ones we cultivate, just those we employ for self-defense against life, the barbed wire along our ingenious perimeters.

I didn't come here for this. None of us did!

6

We know (because we have been told, in a million slivers of edited light) that the world is there to be cajoled or frightened or simply paid into answering back, but if no one speaks up, except in a friendly voice with no fringe of glory in it, does this spell failure?

7

So one day I find that I am speaking. Disaster goes on as before, feasts go on as before. Gratitude and puzzlement. Distress and regret.

One day, at the end of an uneventful afternoon, these words appeared one by one. Regretful feasts continued; puzzling disasters went on being reported; in silence I saw the reflection of a moving mouth and silence was deferred.

8

I was taken aback when I found the obituary buried on page 38, but when I saw the poet's age I was even more shocked: 80. I had always pictured him in his mid-60s at most, because the latest photographs I knew showed him at that age, but also because of the immediacy and amazingly undated durability of his 50-year-old poems.

9

"The library is on fire." But the library is no longer on fire. By now even the smoke from its sodden ashes, which no word of mine can rekindle, has dissipated.

Worse, the reorganization of molecules was only temporary. The falsely stable, pre-conflagration order has returned. In a basement office, scribes sift through the debris.

Yet, a residue is still barely perceptible, at least on a night like this. An after-rush of air, leaves trembling on stately oaks. I'm warming my hands over a pulverized poem.

10

Remember this: it's only the chance of calendar or map that makes the choice of war or peace, several seasons with the mountain partisans or a sinecure in a glass tower.

11

Recall, from the midst of these chilly nights, how once every pronunciamento flew up like a spark in the combustible cities and the eyes of burly discontents swirled like molten glass.

12

Here or elsewhere? Everything leads to a bifurcating road. What is said or what isn't? But the poem, once written, takes both forks.

13

You ran ahead of us, moving on to meet the words you could hear in the distance, and standing by the spillway you founded the illusive dynasty of their sense.

We will be arriving for some time yet, dwelling on your threshold, finding necessary support from your cypress walking stick, Hypnos waking in us.

We'll tend these written vines, climbing in the talismanic night.

14

Elements for a painting: the vivid cloud that follows me and the tangled undergrowth I cannot evade.

We're conduits and this is the overflow, leakage, condensation.

15

I imagine this as nothing more than discardable wrapping or insulation, suitable for inserting between those perfectly clear inches of newsprint and the first page of your Complete Works.

16

I remember reading you on a bus once (in someplace like Boston or Oakland) and, young person that I was, thinking: I'm reading René Char on a bus!

17

Thunder does not only fade, it echoes.

BEFORE WE MET FOR COFFEE

Everything is darkness.

An overgrown field.

In the beginning, too many choices. This is why what your eyes see now is so useful.

A field overgrown with darkness.

A wall.

A friend swallowed up by . . . it was the period of incomplete sentences.

Friend #1: (I want you to) remember (blank) before (blank) and how (blank) was so (blank)!

Friend #2: When they come to ask you about me, if they are biographers, describe all the terrible things I did to other people, but if they are police, describe the terrible things other people did to me.

There's still room for a glimpse of P.L. who died falling down the stairs of the apartment building where he had lived since a boy, except for a few horrific years of deportation which furnished the subject of all his books. I was in that very city recently, with an hour between trains, most of which was spent in a well-known café. I didn't think about him once, and why should I? But what do you care!

This year I promise not to talk about the items surrounding me. And why should I? But what do you care!

I am inching my way towards an incredible freedom of movement, after many years of complicated incapacity. And why should I? But what do you care!

The head swivels around, in small increments, looking for something that would fit perfectly into the space that is being left for it. Such a thing is found, but prior commitments forbid mentioning it.

It is 9:30.

Landscape With Dead Child

I have scruples, of a particular type, that require the strangulation at birth of the many little pages that would have begun their lives by stating the obvious.

A pool—what can that mean?
A pool—what can that symbolize?
A pool—what can that replace?

The other day, a discussion of what an unforthcoming witness nature is, at least in terms of morals and emotions. As any archaeologist will tell you, nature is an excellent witness.

Phase 1: as if the next ten years were certain to be messianic, apocalyptic, heroic.
Phase 2: those ten years, distraction.
Phase 3: a breathing space.

Then one day some clean wind, a mid-July cornfield, a mental appendix of things that will have to be taken care of one day soon.

And I'll have to sit down somewhere and hear why so-and-so can't "be friends" with me any more, and I'll have to go away feeling guilty.

The world is divided into . . . those with music and those who think you have nothing better to do than be with them.

Thank you for not sharing that with me.

It is a beautiful (think of the Barbizon School) day.

I am walking down the road. In 10 steps, within the next 10 steps, I will decide on the form of my masterpiece. Within the 10 steps following whichever steps will have marked my deciding on my masterpiece, I will resolve my conflicts regarding money. Now I'm stopping to make notes of all this. Now I'm recommencing my walk, two families of geese behind me, trees to right and left, pond over there, and a poem in this mind I at least know how to empty out.

LANDSCAPE WITH BOOK

FOR TERRY BERNE

After rapidly discarding the first glittering arrivals
for the crime of being obvious lies
for the crime of sounding too much like
 someone else's obvious lies
for the crime that is too complex for us
 to go into just now,
I at last grew tired of any judicious delay.
Today I . . . oh, no matter.
There were years of drinks and cigarettes on terraces;
we studied the battle formations on the plains below
scrawling harsh marks in the margins of their tactics
while pointing out to each other the exquisite maneuvers
we would have certainly made, given our own commands.
Then we looked away for a minute or two
 (those mouths to feed)
and the scene turned legendary and unaffordable
and now here come the sweepers-up.

Top upper left: green hill-tops with few trees.
Far right: sea (silver-grey), sky (silver-grey).
Center: house (roof tiles, green shutters, vines and trees)
Upper left: olive trees, shack, roosters.
Foreground: black metal railing, balustrade on which
 rests a book with a red, pink, purple, blue,
 green and yellow cover.

To bar your door to the perfectly affable caller
is certainly a start, and not everyone can do it.
It is about five thirty, you are far from home, and not

everyone can do it.
You are waiting semi-patiently, and not everyone can do it.
And she is also waiting,
for something no one has yet thought of saying to her,
but you are not sure if the necessary equipment is
 close to hand.

Just appeared: woman in blue housecoat sweeping second floor
 balcony of house.

Better, a list of "don'ts"
beginning with a strong warning against—well
 do I really have to spell it out?
They were loved because they worked so hard,
but so did the others, with unequal results.
I think *we're* expected to understand, or at least keep
 quiet about it
or did *I* get it all horribly wrong?

IN THE MEANTIME
FOR JOHN YAU

Security men were opening limousine doors for
 diplomats in transit,
someone was reading a page of weak writing
 or seeing *Pierrot le Fou* for the fifth time,
skin stretched across a young ribcage
warmed to the touch of uncertain fingertips...
these and a thousand other vignettes
or whatever we might later agree to call them
massed in the plaza with placards and banners.
Above them the moon rose, over the official dome,
reminding three or four of some wholly incidental occasion
that, for no even guessable-at reason had been
 carried over through successive eras
like the sum of a previous equation.
Each of those so afflicted had a different image
 with which to contend.
For one, bric-a-brac in a shop window
 a February evening eight years previous;
for another, a bartender telling a joke in a
 long defunct nightclub.
It seems, to change the subject, sort of, that we have to
 spend a lot of time thinking
about those who practice the same profession as ourselves,
how some are better than us at it, so much better
 it hardly seems possible
that our diplomas read the same, and then those sinister
 figures, always distant
but active, like crows on the plains at sunset, who botch

every operation and yet are allowed to bungle on
 for decades,
as if, somehow, incredibly, no one had noticed or,
 worse, *had* noticed and, gruesomely, approved.
Hunched late over a desk, or on the porch swing not
 following the lyrics of your latest companion,
in the background the radio reporting an
 incident-free state visit,
your hand moves towards the lurid cover of
a mystery with extra pages.

Error And After

<center>1.</center>

Sometimes reading these books they write or reading about these books they write makes me also want to write books and sometimes it makes me want to not write any books at all, at least any books like the books they write, which I sometimes read or read about.

When I make rude gestures (as I am doing now) in the direction of the books they write it does not mean that I think it is easy to write those books. On the contrary, their authors belong to a select order of perfectly conditioned imaginations, and they don't take naps between sentences, and they know how to generate convertible currency. Attempting a page like theirs, I'm left breathless at the bottom. So yes, writing any book is not easy, even a book to which a rude gesture is the only possible response.

Once books were divided into those that were difficult to write and those that were not. (Of those books we now only read the former.) With us however all books are now equally difficult (or not-so-difficult) to write and we read all of them (or none of them), not realizing, except maybe some of us and only recently and only a little, that it is not the ease or non-ease or even the difficulty or non-difficulty of books that matters—what matters about books is who wrote them.

There are books and there are people who write books and there are different kinds of people who write different kinds of books. I've just been reading a book and wondering if the person who wrote it is really as corpse-like as his book. Maybe, maybe not.

"Why (outside of the common appetites) do I want to

<center>68</center>

insert myself into this story?" I ask myself in the drowsy interval between glances—the window, the hand, the lips. If, after reading their books or reading about their books, I find myself wanting to write more of them, perhaps it is simply because I want someone to know, now or later, that their way of putting things or not putting things is or was not the only way people were like in these years in these places. And when I want not to write books and not read them and not read about them or write about reading them or write about writing them or not writing them it is simply because I am left:

Motionless in Fear of Guilt by Association

and

Absent in Anger at the Music of the So-Called

2.

Each measured and remeasured utterance, pleading its
 case somewhere
in the crowded terminal of borrowed voices and
 broken promise.

Taught first to respect the difficulty of seriousness,
taught again to relegate it to histories of thin blood,
only a kind of wry surrender remained,
and the daily extinction of styles, and smiling stamina.

After the phrases that meant something
came those sounding like they meant something,
instant emblems broadcasted on the page,
tiny mirrors in which the surrounding architecture
winked back at you.

If only silence were contagious.
I have before me two lists
yet find it hard to concentrate this afternoon,
denser with hanging need
than at the outset of volume one.
A long dissolve is what it seems to resemble most.
So, what can be done with those who figure on the first?
Public scolding, followed by semi-oblivion?
And the others? To become one of their number
you need letters of blinding recommendation,
which others call poems.
I write to you from
the café table where *Le Parti Pris des Choses* and
 Paid on Both Sides overlap,
the passenger seat of a Buick being driven by the
 ghost of Laura R,
the outskirts of Alphaville,
a rowboat in the middle of a lake whose rippling waters scatter
resourceful clouds whose intentions were too dependent upon the
gracefulness of their dissolution,
the exact place where we've made our sometimes rendezvous.

Rue Linée

The fiancée of cinema left standing at the young doors.
She would like to cry and we would like her to cry.
Maybe soon she will cry.

When there is too much of it to know what to do
 with all of this distaste,
when you have just escaped from a nap and the fog
 of identity stings a little,
when the hollowness of the chambers accuses you
and the once easy recourse to the smoky and photogenic
 has been disallowed,
there is still your breath, stronger,
and whole days devoid of the old you.

GREETINGS FROM FILICUDI

(TO ELENA BERRIOLO)

Residual, this role, and also, perhaps, my claim to the life around it. A dirge is probably appropriate, but one with the thinness of a veil behind which a crowd of very happy chorus girls are limbering up.

Everyday more distant from each of those early models, and not harboring very many warm thoughts about my fatherland, I guess I now understand (despite our many differences) that wealthy amateur's decision to persevere, in spite of mockery and indifference, if only to draw the great public's attention to his overly prompt genius. Here it is not the virtues of any particular work (god knows the early ones were awful) so much as the conviction out of which they grew.

One could say: he gave up cigarettes when, shortly after his first belated appearance in print, he realized that no flattering cameras were focused on his heroic struggles. Only a certain kind of certainty could argue for that damage.

The truth, however: I quit smoking because I hoped it would give me more years with you.

Years yes (hearts and lungs permitting), but where? Is it only because of the sordid incidents recalled by each tree and meadow (and worse, this place is wholly without trees and meadows) that I wish to go over to your side?

I put on new clothes, breathe a different kind of air, bend to another kind of work.

ACCORDION MUSIC

I thought I would speak
today I thought I would speak about
earlier today I thought I would speak about something that
concerns us all
it was because of something I can't yet put into words that earlier
today I thought I would speak about something that concerns us
all in a way that isn't immediately clear

there are days
I pretend that there are days that are somehow different
it is because of you that I pretend that there are days that are
somehow different, days that call for
I was cursed with a flat-footed, hard-boiled, no-nonsense dossier
but now it is because of you that I pretend that there are days
that are somehow different, days that call for an imaginative
inconsistency that would only appeal to a wholly different
clientele

they rise up
I am amazed the way they rise up almost every day
what I have to say about errands and duties is that I am amazed
the way they rise up almost every day like (I'm not sure what
goes here)
as I wade and dodge through them what I have to say about
errands and duties is that I am amazed the way they rise up
almost every day like (I'm not sure what goes here but if I keep
my mind open for another minute maybe a couple of sufficiently
unexpected and appropriate similes will make themselves known
to me)

Screw you: phone calls I have to make, things I should buy
today, unanswered letters, some going back years—I'm writing
and as I wade and dodge through them what I have to say about
errands and duties is that I am amazed the way they rise up
almost every day like (I'm not sure what goes here but if I keep
my mind open for another minute maybe a couple of sufficiently
unexpected and appropriate similes will make themselves known
to me or not I guess, surrendering to these shadows with a curse)

green like my mother
in April the leaves come, green like my mother, reaching out
drunk or not drunk at New Year's, the bad weather of February
and March we're ready for, then in April the leaves come, green
like my mother, reaching out into the warming air
reaching the age when you can start to speak in fractions of
centuries, oh well; drunk or not drunk at New Year's, the bad
weather of February and March we're ready for, then in April the
leaves come, green like my mother, reaching out into the
warming air, colorless like water and tears

STRAY DEDICATION

to
those
from whom
the why of how
and what of when
and where of which
was

withheld

A Restoration

They had better things to do when the artist was still alive
but the work of a serene mind is never serene.
So much was carried away
excluding though the word "sun"
and part of the bridge.
She, who appears once or twice,
taught me the poetry of the Lagoon
and how to dodge a fresh sea wind.

While the artist was still alive,
the supreme excitement was renewing the style of sin.
It would have been easy to be damped
by the cold realistic air of his time,
even easier to combine great architecture
and the allegorical paintings to be had for pennies then.

So, who fooled whom with those scenes of village life?
This is my life even though
its perspective is intentionally altered.

While the artist was still alive no one
cared about valuable documentary evidence.
They just searched for faces in the shadows
at the borders of that happy moment
on our canal of broken sun.

Born in Lawrence, Kansas, in 1955, Raphael Rubinstein grew up in Tucson and the San Francisco Bay area and attended Bennington College. Limited editions of his writing include *The Scale of Commodes* (1990, illus. Enrico Baj) and *Poste Restante* (1992, illus. Shirley Jaffe). *The Basement of the Café Rilke* is his first collection of poems. A volume of his selected art criticism is forthcoming in French translation from L'Harmattan (Paris). He lives in New York City where he works as associate editor of *Art in America*.